WILDLIFE
PHOTOGRAPHER
OF THE YEAR

Highlights Volume 4

Published by the Natural History Museum, London

Competition and winners captions editor: Rosamund Kidman Cox
Winners caption writers: Tamsin Constable and Jane Wisbey
Project editor and people's choice captions: Gemma Simmons
Internal design: Bobby Birchall, Bobby&Co Design
Cover design: Lewis Morgan
Image grading: Stephen Johnson www.copyrightimage.com
Colour reproduction: Saxon Digital Services UK
Printing: Printer Trento Srl, Italy

Front cover: The golden couple by Marsel van Oosten

Contents

Foreword

What makes some images better than others? Some are better, of course, or there would be no basis for a competition, but how do you decide? There is no formula and no simple answer. For the judges, it is more like a search for gems, for precious photographic moments or stories. It is exciting but also a great responsibility. Selecting just 100 images while discarding possibly 45,000 is done in the knowledge that winning in this, the world's largest natural history competition of any kind, can transform a photographer's life. It gives recognition and fortitude to continue with a demanding profession – one with rewards that are generally more emotional than financial.

There is a certain structure to the selection process. It is provided by the categories, chosen to represent a range of subjects that reflect the ways we see and interact with the natural world. Within the structures, the gems the judges are looking for mainly concern originality, not so much of the subject but the viewpoint. Beyond originality, what influences a decision can be as much an emotional reaction to a picture as an intellectual judgement. Surprise can give an initial advantage, but the immediate impact often wanes when you see the picture again. By comparison, pictures can grow on you as you explore the content – certainly when you have time to reflect and revisit. There is also the intangible element of a picture that is difficult to put into words but speaks to feelings and even memories. At the end of the process, there may be such a division of opinion over two pictures that another rises to the top through compromise.

There are also judging criteria beyond the visual effect of a photograph. First, there are ethical considerations. A picture can be discarded if there is any suspicion that an animal has been restrained or distressed. And strict attention is given to comparing submitted images in the finals with the camera's 'raw' unprocessed files (effectively the digital negatives) for any manipulation beyond processing and what is allowable in the rules. Only after the judging, when the names of the photographers are finally revealed and the stories behind the pictures gathered together is it possible to assess what the whole represents. This year, for example, it became apparent that we had more female photographers in the roll-call than ever before. And just as heartening, among the young photographers, previous winners were showing up again as they rose through the age ranks.

Sometimes technical innovations lead to fresh perspectives – images that, in the past, would have been impossible or difficult to take. For the first time, images taken from drones have featured in this year's competition. Camera-trap shots – shots impossible to take in any other way, of animals going about their normal business – are now regularly in the finals. This year in particular they have given us impressive views of animals within the panoramas of their environments. Of course, some of the very best are straight shots of behaviour – something this competition has always championed – resulting from a photographer investing time in understanding an animal and knowing where and when to capture that unforgettable shot. Storytelling also remains a strong element. You may not like some of the photojournalism shots, but then that may reflect a dislike of what they reveal about human behaviour.

However you feel about a picture, whether it is one you feel should have won or one you feel shouldn't have, you will be mirroring the judges' discussions – and those of other viewers – about what qualifies as the best of the best. And passing judgement is, of course, part of the enjoyment. This year's overall award-winner is in one sense traditional – a portrait. But what a striking one, and what magical animals. It is a picture you linger over – a symbolic reminder of the beauty of nature and how impoverished we are becoming as nature is diminished. It is an artwork worthy of hanging in any gallery in the world.

Rosamund Kidman Cox
Chair of the Jury, Wildlife Photographer of the Year 2018

The Competition

Wildlife Photographer of the Year is a showcase for the world's best pictures of wildlife. It provides both an inspiring annual catalogue of the wonders of nature and a thought-provoking look at our complex relationship with the natural world. It acts as a forum for all aspects of wildlife photography, and it provides a meeting place for practitioners. It also continues, after more than 50 years, to chart the progression of nature photography.

Anyone anywhere in the world can enter the competition – professional or not, old or young. To give the greatest scope for entries, it offers 16 categories and for those 17 and under, there is a dedicated part of the competition. All the winners are brought together to attend the major awards celebration and the exhibition opening at the Natural History Museum in London. Their images also receive the greatest possible coverage, through the national and international travelling exhibition, the book and its translations and the extensive worldwide publicity.

This year, the competition received 45,028 entries from 95 countries. That's a massive number for any jury to distil to just 100 pictures. So judging requires two extensive sessions, one lasting two weeks and the second lasting a week, when the judges gather at the Natural History Museum to review the final selection. The choices are made without the jury knowing the identity or nationality of the entrants. The judges are looking for artistry and for fresh ways of seeing nature. Great emphasis is placed on subjects being wild and free, and on truth to nature, which is why there are strict rules on digital manipulation.

The next wildlife photographer of the competition opens on 22 October and closes on 13 December 2018. For the categories and rules see www.wildlifephotographeroftheyear.com

Judges

Alexander Badyaev (Russia/USA), biologist and wildlife photographer

Clay Bolt (USA), natural history and conservation photographer

Ruth Eichhorn (Germany), photo editor and curator

Angel Fitor (Spain), naturalist and underwater photographer

Sandesh Kadur (India), wildlife photojournalist and film-maker

Ian Owens (UK), Director of Science at the Natural History Museum

CHAIR
Rosamund 'Roz' Kidman Cox (UK), writer and editor

The Wildlife Photographer of the Year 2018

The Wildlife Photographer of the Year 2018 is **Marsel van Oosten**, whose picture has been chosen as the most striking and memorable of all the entries in the competition.

The golden couple

Marsel van Oosten

THE NETHERLANDS

A male Qinling golden snub-nosed monkey rests briefly on a stone seat. He has been joined by a female from his small group. Both are watching intently as an altercation takes place down the valley between the lead males of two other groups in the 50-strong troop. It's spring in the temperate forest of China's Qinling Mountains, the only place where these endangered monkeys live. They spend most of the day foraging in the trees, eating a mix of leaves, buds, seeds, bark and lichen, depending on the season. Though they are accustomed to researchers observing them, they are also constantly on the move, and as Marsel couldn't swing through the trees, the steep slopes and mountain gorges proved challenging. Whenever he did catch up and if the monkeys were on the ground, the light was seldom right. Also, the only way to show both a male's beautiful pelage and his striking blue face was to shoot at an angle from the back. That became Marsel's goal. It took many days to understand the group's dynamics and predict what might happen next, but finally his perseverance paid off with this gift of a perfect situation, with a perfect forest backdrop and perfect light filtering through the canopy. A low flash brought out the glow of the male's golden locks to complete the perfect portrait.

Nikon D810 + Tamron 24-70mm f2.8 lens at 24mm; 1/320 sec at f8; ISO 1600; Nikon SB-910 flash.

Marsel van Oosten

A training in art and design led to a successful career as an art director, but a love of wildlife and a passion for photography finally took him from life in the fast lane to the challenges of survival as a nature photographer. Exhibited and published worldwide, Marsel has already won many awards and runs his own nature-photography tours.

It's simply a most beautiful portrait of one of the world's most striking primates, superbly lit and perfectly posed against a rich green backdrop, as if for a studio session. There is intimacy and drama here, too. What is their relationship and what are they watching so intently? It's a picture you linger over and wonder about. It's also a picture that you would never tire of looking at.

Roz Kidman Cox

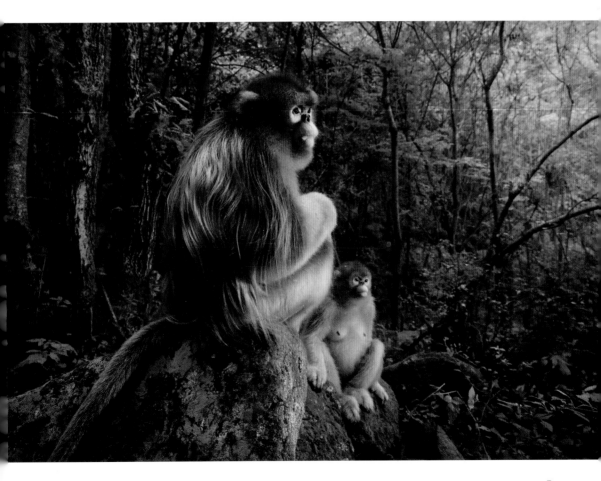

Portfolio

The Wildlife Photographer of the Year Portfolio Award is given to one photographer whose outstanding collection of images focuses on a specific subject or photographic approach. This year's winner, Javier Aznar González de Rueda, provides us with eye-level close-ups of the insect world, executed with technical brilliance.

Sugar on tap

Javier Aznar González de Rueda

SPAIN

In an Ecuadorian cloud forest, a stingless bee gently taps a treehopper nymph to collect droplets of sugary honeydew. The treehoppers feed on plant sap and excrete any excess as a sweet liquid. This carbohydrate-rich secretion is so delicious to the bees that they seek to keep their personal supply secure. In return for sustenance, they protect the treehoppers from predators and reduce the risk of harmful fungal growth by cleaning up excess honeydew. But rather than waiting patiently to be fed, the bees elicit their own drinks. Javier describes how: 'When a bee touched a nymph on the back of the abdomen with its antennae, the nymph released a droplet of honeydew, which the bee sucked up.' It took several days for Javier to capture this precise moment – a behaviour rarely observed in such detail – telling the intricate but easily overlooked story of this mutual relationship.

Canon EOS 5D Mark II + 65mm f2.8 lens; 1/160 sec at f14; ISO 640; Yongnuo + Nikon flashes; Sirui tripod + Uniqball head.

Javier Aznar González de Rueda

Javier is a biologist and wildlife photographer with a passion for the world's little-known smaller creatures. A member of the International League of Conservation Photographers (iLCP), he believes in the power of photography to help learning and conservation. Javier often works at night, when many of his subjects are most active, photographing them in their natural surroundings, while taking care not to disturb them. This portfolio is the result of a year in the Ecuadorian Amazon and in cloud forest observing treehoppers.

It takes a deep understanding of natural history to produce images that are at once so strikingly beautiful and artistic, yet so rich in complex and intricate biological interactions. These behaviours are seldom seen, much less photographed in the wild with such extraordinary skills.

Alex Badyaev

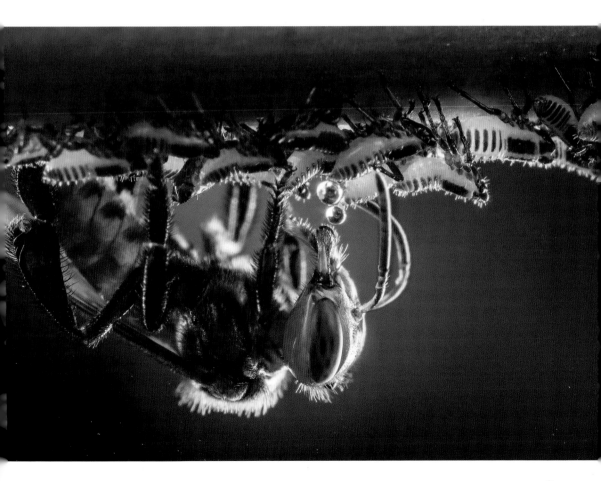

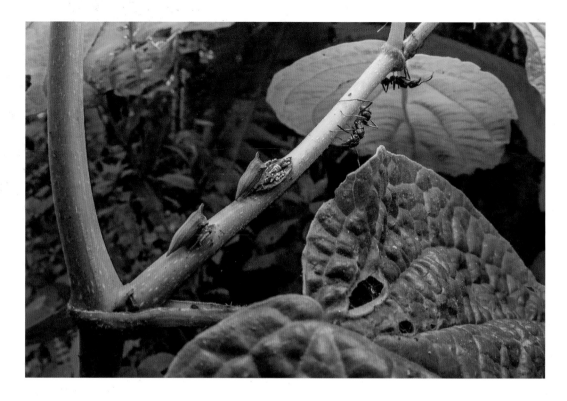

Rainforest relations

Two female *Metheisa* treehoppers watch over their eggs in Ecuador's El Jardín de los Sueños cloud-forest reserve. Before laying, each used its ovipositor – the rigid tube through which the clutch is laid – to carve a long incision in the plant stem, which now cradles the eggs. A couple of ants patrol the stem, ready to attack any predators or parasitoids that might threaten the small bugs. The ants' reward is the sweet honeydew that the mother treehoppers excrete after sucking up plant sap. Fascinated by the intricacies of the behaviours he observed, Javier chose a wide angle to reveal the tiny players absorbed in the duties of their small world.

Nikon D810 + Tokina 10-17mm f3.5-4.5 lens at 16mm; 1/15 sec at f32; ISO 800; Yongnuo flash; Sirui tripod + Uniqball head.

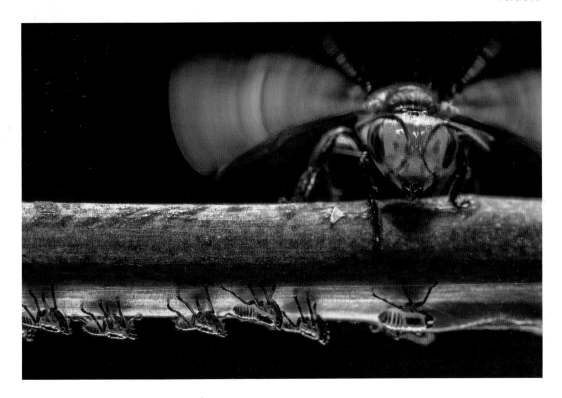

Bee on guard

Javier was familiar with ants tending treehopper nymphs, but he had never before seen a bee acting as their protector. He returned to the spot, in Napo in the Ecuadorian Amazon, for several consecutive days, keen to document this lesser-known relationship. 'Sometimes, just one bee would be guarding the nymphs,' says Javier, 'though once, there were eight or more.' In return for their diligence, they were treated to nutritious drops of honeydew produced by the nymphs. The bees were so active that it was a challenge to capture their behaviour. Javier's patience was rewarded in this face-off – a bee with wings abuzz, painting rainbows in their wake, and the nymphs safely lined up beneath.

Canon EOS 5D Mark II + 65mm f2.8 lens; 1/160 sec at f13; ISO 800; Yongnuo + Nikon flashes; Sirui tripod + Uniqball head.

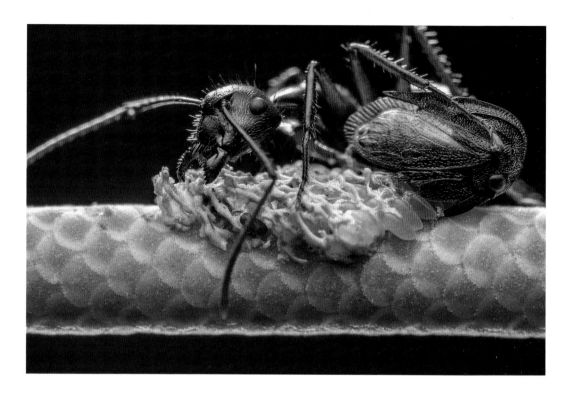

The odd couple

The tiny *Erechtia* treehopper (right) makes a very caring mother. She lays her eggs on a flower stem, covers them with a waxy secretion to protect them against desiccation, predators, parasitoids and fungi, and then stands guard over the clutch. Just 3 millimetres (an eighth of an inch) long, with a distinctive helmet extending along her thorax, she enlists the help of a large ant (left) with fearsome jaws to see off any threats. 'I noticed that an individual ant would look after a particular treehopper,' says Javier. At such a high magnification, the depth of field (amount in focus) was very narrow. 'It took me a few days', he says, 'to capture the ant's head and the treehopper aligned in the same plane' and therefore in focus.

Canon EOS 5D Mark II + 65mm f2.8 lens; 1/100 sec at f10; ISO 640; Yongnuo + Nikon flashes; Sirui tripod + Uniqball head.

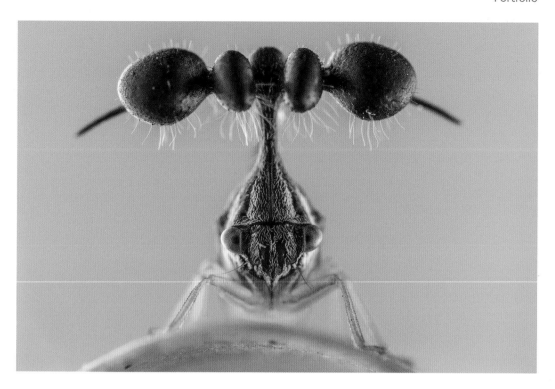

Little big head

The outlandish appearance of the *Bocydium* treehopper belies its shy
nature. Javier found just two in the three months he spent looking
for them in the Amazon – and the first flew away before he could
photograph it. Nearly all treehoppers have enlarged thoracic structures,
known as helmets, which develop from pairs of tiny wing-like forms that
expand and fuse above the body. They are often cryptic in function,
disguising the treehoppers as thorns or leaves to match their host plants.
With such an eye-catching array of bristly, hollow spheres of chitin over
its head, *Bocydium* cannot be trying to hide. It seems more likely that
the aim is to deter predators in some way. Taking care not to scare the
bug away, Javier captured its portrait head-on for maximum impact.

**Canon EOS 70D + 65mm f2.8 lens; 1/200 sec at f7.1; ISO 100; Yongnuo +
Quadralite Reporter flashes; Sirui tripod + Uniqball head.**

Hellbent

David Herasimtschuk

USA

Drifting downstream in Tennessee's Tellico River, in search of freshwater life, David was thrilled to spot this mighty amphibian with its struggling prey, a northern water snake. Growing up to 75 centimetres (29 inches) long, the hellbender is North America's largest aquatic salamander. The intense drama was over in just a few minutes, when the hellbender tried to reposition its bite, the snake pushed free from its jaws and escaped. David's quick reactions captured this rarely seen behaviour, portraying the 'diabolic charisma' of the giant hidden just beneath the surface.

Sony a7R II + 28mm f2 lens + Nauticam WWL-1 lens; 1/60 sec at f13; ISO 1250; Nauticam housing; Inon Z-240 strobe.

This image is a catastrophe in terms of colour, but despite this, the image is just stunning, as the photographer was able to shoot an attack of a rare and ancient giant: a hellbender salamander. A brilliant image of a moment of life and death.

Ruth Eichhorn

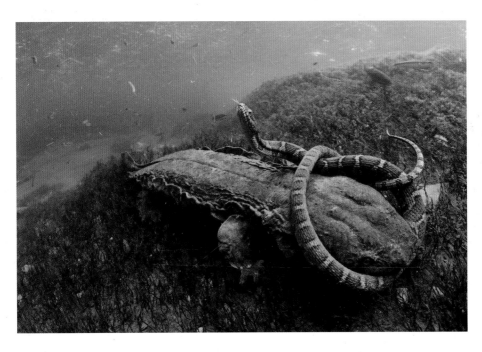

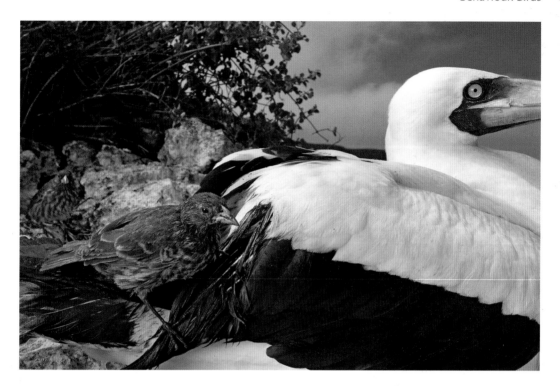

Blood thirsty

Thomas P Peschak

GERMANY/SOUTH AFRICA

When rations run short on Wolf Island, in the remote northern Galápagos, the sharp-beaked ground finches become vampires. Their sitting targets are Nazca boobies and other large birds on the plateau. Boobies thrive here, nesting among dense cactus thickets and fishing in the surrounding ocean. Finches have a tougher time. The island has no permanent water and little rainfall and they rely on a scant diet of seeds and insects and, on occasion, they drink blood to survive. Tom shot the scene at bird's eye level to capture the one female feeding and another waiting just behind.

Nikon D5 + 16-35mm f4 lens; 1/200 sec at f20; ISO 160; Profoto B1X 500 AirTTL flash.

To be able to tell a story in a single shot is a rare skill, involving planning, knowledge and imagination. And to do that with artistry deserves huge applause.

Roz Kidman Cox

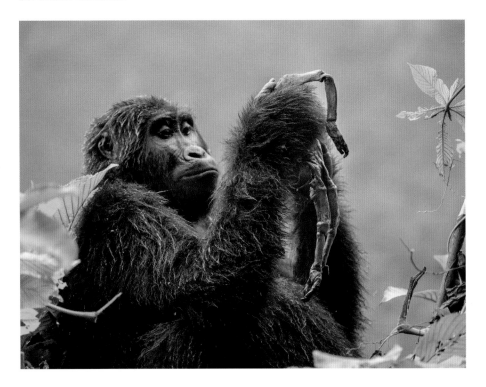

Kuhirwa mourns her baby

Ricardo Núñez Montero

SPAIN

Kuhirwa, a young female member of the Nkuringo mountain gorilla family in Uganda's Bwindi Impenetrable Forest, would not give up on her dead baby. Guides told Ricardo that she had given birth during bad weather and that the baby probably died of cold. At first Kuhirwa had cuddled and groomed the body, moving its legs and arms up and down and carrying it piggyback like the other mothers. Weeks later, she started to eat what was left of the corpse, behaviour that the guide had only ever seen once before. Kuhirwa's behaviour can be understood as mourning, without the need to speculate about her thoughts.

Nikon D610 + 70-300mm f4.5-5.6 lens at 185mm; 1/750 sec at f5; ISO 2200.

Do animals feel? Do they think about the meaning of life? This unique photograph raises those and many other questions, which immediately made me fall in love with it.

Angel Fitor

Mud-rolling mud-dauber

Georgina Steytler
AUSTRALIA

It was a hot summer day, and the waterhole at Walyormouring Nature Reserve, Western Australia, was buzzing. Georgina had got there early to photograph birds, but her attention was stolen by the industrious mud-dauber wasps, distinctive with their stalk-like first abdominal segments. They were females, busy digging in the soft mud at the water's edge and then rolling the mud into balls to create egg chambers to add to their nearby nests, which are made completely out of mud. It took Georgina hundreds of attempts to achieve her ideal shot – each wasp displaying an aspect of their quintessential mud-handling skills.

Canon EOS-1D X + 600mm f4 lens + 1.4x extender; 1/4000 sec at f8; ISO 1000.

Subtle, delicate and masterfully executed, this image has a lot going for it. An instant favourite amongst all the judges.

Sandesh Kadur

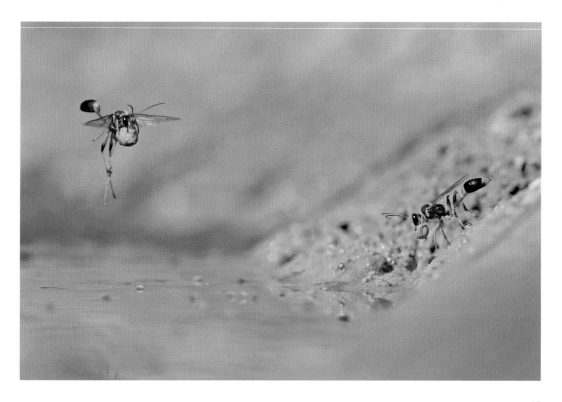

Desert relic

Jen Guyton
GERMANY/USA

The cones of a female welwitschia reach for the skies over the Namib Desert, proffering sweet nectar to insect pollinators. Endemic to Namibia and Angola, welwitschia endures harsh, arid conditions, usually within 150 kilometres (90 miles) of the coast, where its leaves capture moisture from sea fog. Jen's challenge was to find a striking way to photograph what can be seen as just a pile of old leaves. After trekking all day over hot sand, she started to shoot just as the sun was going down – she adopted a low, wide angle to catch the vibrant tones and to display the plant's architecture against the expansive landscape.

Canon EOS 7D + Sigma 10-20mm f4-5.6 lens at 10mm; 1/100 sec at f22; ISO 400; Venus Laowa flash; Manfrotto tripod.

The world of plants is so vast, diverse and stunning. To look at this image in a natural setting, with a dramatic sky and a horizon, is a feast for the eyes.

Ruth Eichhorn

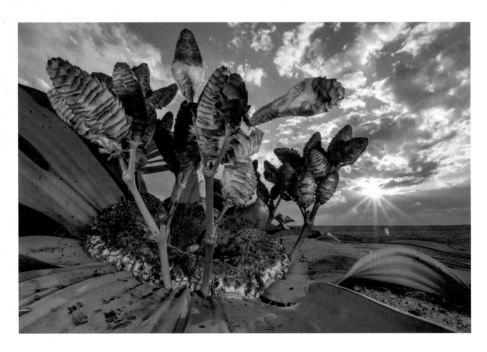

Bed of seals

Cristobal Serrano

SPAIN

A small ice floe in the Errera Channel at the tip of the Antarctic Peninsula provides barely enough room for a group of crabeater seals to rest. It's the end of summer in the Antarctic, and so sea ice here is in short supply. The seals are dependent on sea ice, for resting, breeding, avoiding predators, and accessing feeding areas. Positioned in a rubber dinghy in the channel beside the floe, Cristobal waited until the sea was relatively calm before launching his drone. The batteries would not last long in the cold, so he flew the drone 'high and smoothly ... using low-noise propellers to avoid disturbing the seals'.

DJI Phantom 4 Pro Plus + 8.8-24mm f2.8-11 lens; 1/200 sec at f5.6; ISO 100.

A combination of stability and fragility, of rest and motion, of ice-cold geometry and organic grace, of blissful calm and impending danger – this image recalibrates your senses and makes you pause and think.

Alex Badyaev

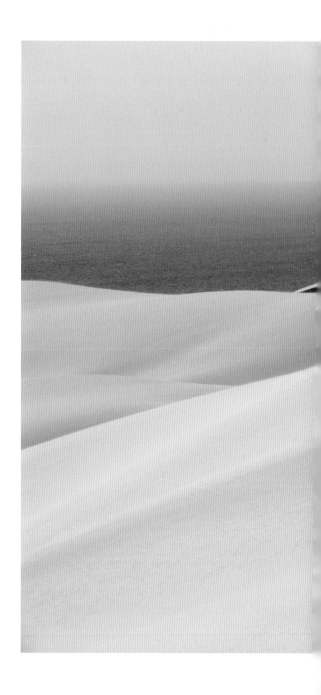

The endless coastline, subtle colours, patterns, shapes and how everything merges together make this a top shot for me. I could stare at this image endlessly and never tire.

Sandesh Kadur

Windsweep

Orlando Fernandez Miranda
SPAIN

Standing at the top of a high dune on Namibia's desert coastline, where mounds of wind-sculpted sand merge with crashing Atlantic waves, Orlando faced a trio of weather elements: a fierce northeasterly wind, warm rays of afternoon sunshine and a dense ocean fog obscuring his view along the remote and desolate Skeleton Coast. Such eclectic weather is not unusual in this coastal wilderness. It is the result of cool winds from the Benguela Current, which flows northwards from the Cape of Good Hope, mixing with the heat rising from the arid Namib Desert to give rise to thick fog that regularly envelopes the coast. As it spills inland, the moisture from this fog is the life-blood for plants and insects in the dry dunes. Orlando framed his shot using as a focal point the sharp ridge of sand snaking out in front, ensuring that the sweep of wind-patterned dunes to his right remained in focus, and kept the distant fog-shrouded coast as a mysterious horizon.

Canon EOS 5D Mark III + 70-200mm f2.8 lens at 110mm; 1/500 sec at f11; ISO 100.

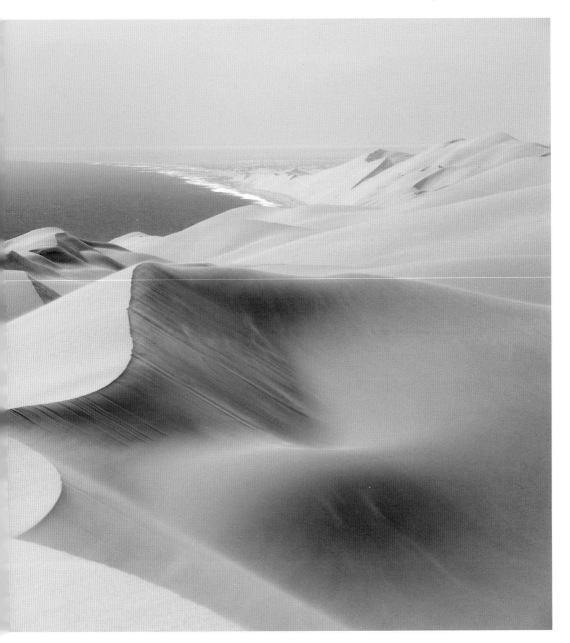

The vision

Jan van der Greef

THE NETHERLANDS

Perfectly balanced, its wings vibrating, its tail opening and closing, with its tiny feet touching the spike for just an instant, an eastern mountaineer hummingbird – a species found only in Peru – siphons nectar from the florets of a red-hot-poker plant, or torch lily. Jan noticed that when the bird moved behind a spike and its tail closed for a moment, a beautiful cross appeared. The low position of his wheelchair allowed him to set the spike against the sky, framing it with a dark surround of bushes. It took two half days for Jan to get his desired shot, setting his camera to capture 14 frames a second in order to do so.

Canon EOS-1D X Mark II + 500mm f4 lens; 1.4x III extender; 1/5000 sec at f5.6; ISO 4000; Gitzo tripod + Jobu gimbal head.

This is a natural scene shot with vision. There is no artifice other than the choice of black and white, but there is craft and imagination.

Roz Kidman Cox

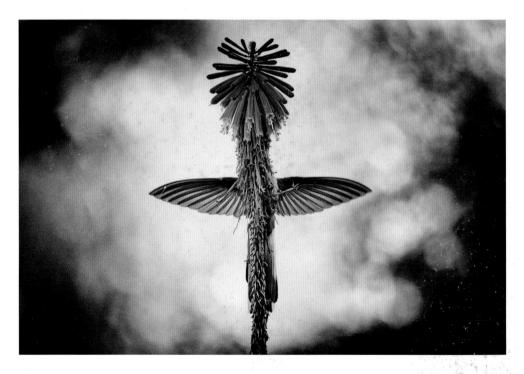

The ice pool

Cristobal Serrano

SPAIN

On a cloudy day – perfect for revealing textures of ice – Cristobal scoured the Errera Channel on the west coast of the Antarctic Peninsula. The constant current through this relatively calm stretch of water carries icebergs of all shapes and sizes. Selecting one that looked promising, Cristobal launched his low-noise drone. The drone's fresh perspective revealed an ice carving, whittled by biting winds and polar seas. Warmer air had melted part of the surface to create a clear pool within the sweeping curves of ice. The sculpture was set off by the streamlined forms of a few crabeater seals and simply framed by the deep water.

DJI Phantom 4 Pro Plus + 8.8-24mm f2.8-11 lens; 1/120 sec at f4.5; ISO 100.

From above, many things that are familiar look very different. I could fantasize for hours about this image, which could show the profile of a face or a heart-shaped swimming pool. It is open to everybody's interpretation and that makes it intriguing.

Ruth Eichhorn

Night flight

Michael Patrick O'Neill

USA

On a night dive over deep water – in the Atlantic, far off Florida's Palm Beach – Michael achieved a long-held goal, to photograph a flying fish so as to convey the speed, motion and beauty of this 'fantastic creature'. By day, they are almost impossible to approach – if startled they can glide for several hundred metres (more than 650 feet). At night, they are more approachable, moving slowly as they feed on planktonic animals close to the surface. In a calm ocean, Michael tried various camera and light settings until he achieved this 'innerspace' vision of a flying fish.

Nikon D4 + 60mm f2.8 lens; 1/8 sec at f16; ISO 500; Aquatica housing; two Inon Z-220 strobes.

I cannot remember having seen such a sophisticated representation of a flying fish taken at night. This image is full of beauty and full of seduction.
Ruth Eichhorn

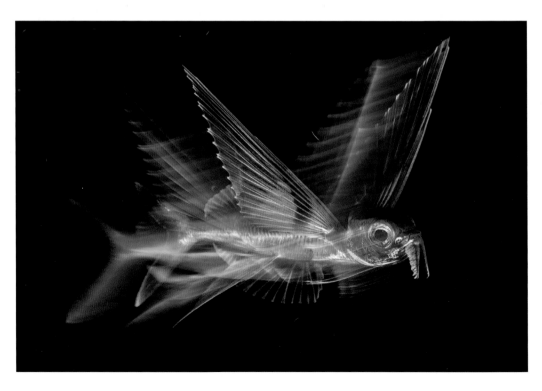

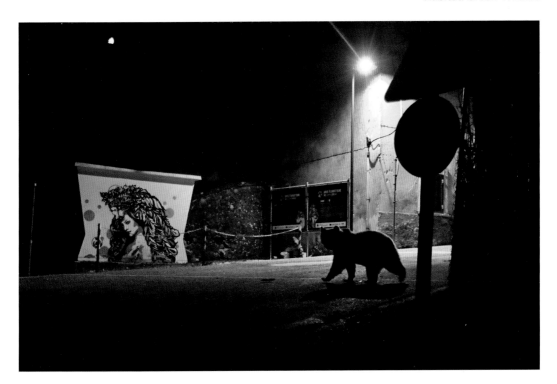

Crossing paths

Marco Colombo
ITALY

A shadowy movement caught Marco's eye as he drove slowly through a village in the Abruzzo, Lazio and Molise National Park in Italy's Apennine Mountains. It was late evening, and he thought there was a chance that it might be a Marsican brown bear – only 50 or so bears remain. Stopping the car, he switched off the lights to avoid stressing the animal. He had just a few minutes to change lenses and prepare to take a shot through the windscreen before the bear walked out of the shadows and across the road, disappearing into the dark of the woods.

Nikon D700 + 28-70mm lens at 70mm; 1/50 sec at f4; ISO 6400; MaGear harness.

A closer look at the graffiti and posters brings a whole new meaning to human-wildlife coexistence – an ingeniously simple and yet masterfully multidimensional capture.

Alex Badyaev

The sad clown

Joan de la Malla

SPAIN

Timbul, a young long-tailed macaque, puts his hand to his face to try to relieve the discomfort of the mask he has to wear. His owner is training him to stand upright for his street show. When he's not training or performing, Timbul lives chained up in his owner's yard in Surabaya, Java. Animal-welfare charities are working to reduce the suffering of these monkeys. Joan spent a long time gaining the trust of the owners, 'They are not bad people,' he says, 'and by doing street shows, they can afford to send their children to school. They just need other opportunities to make a living.'

Nikon D810 + 24-70mm f2.8 lens; 1/250 sec at f2.8; ISO 100; Speedlight SB-800 flash.

This is a mastery use of the genre of tragicomedy, one of the most powerful storytelling resources to shake people's consciences and trigger change.

Angel Fitor

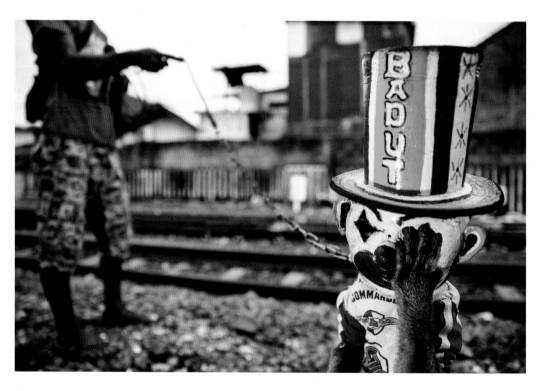

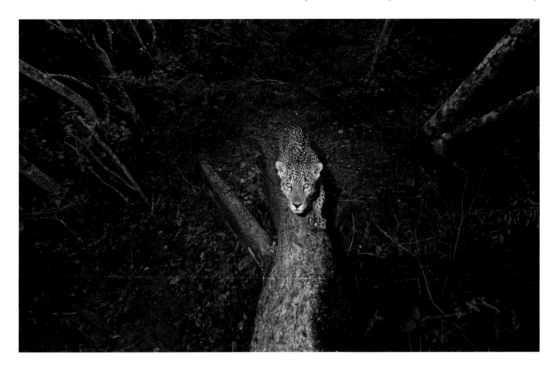

GUNNING FOR THE JAGUAR

Signature tree

Alejandro Prieto

MEXICO

A male jaguar sharpens his claws and scratches his signature into a tree on the edge of his mountain territory in the Sierra de Vallejo, Nayarit, Mexico. The tree has soft bark, allowing for deep scratch marks that, backed by pungent scent, are a clear warning not to trespass. Jaguars need vast territories to have access to enough prey. But in Mexico, habitat is being lost at a rapid rate as forest is cleared for crops or livestock or for urban development.

Nikon D3300 + Sigma 10-20mm lens; 1/200 sec at f9; ISO 200; waterproof camera box; two Nikon flashes + plexiglas tubes; Trailmaster infrared remote trigger.

It's a story with readable elements. Words will add detail, but there is little doubt what the storyline is: the conflicting relationships between the people and the jaguar.

Roz Kidman Cox

Cats for cows

Conflicts with cattle ranchers are, after habitat loss, the greatest threat to the jaguar's survival. When ranchers encroach on forest occupied by jaguars, illegal hunting becomes rife, wiping out the jaguar's prey, and eventually the jaguar attacks a cow. Normally it eats only part of the animal and then returns a day or so later to finish its meal, by which time ranchers may have laced the carcass with poison or are waiting with a shotgun. 'When a jaguar kills a cow, it's usually a death sentence,' says Alejandro. The owner of this cow invited Alejandro to come and wait for the jaguar to return to finish its meal.

Nikon D3300 + Sigma 10-20mm lens; 1/200 sec at f8; ISO 200; home-made waterproof camera box; two Nikon flashes + plexiglas tubes; Trailmaster infrared remote trigger.

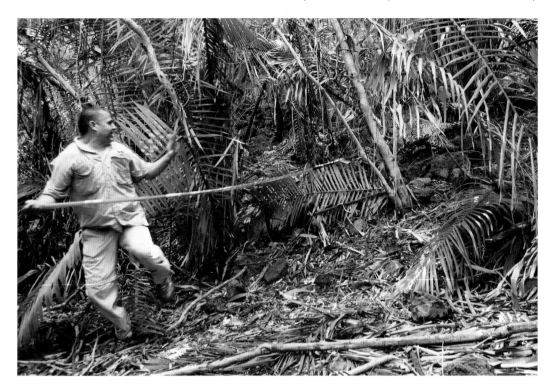

The good hunter

Enraged, the young male jaguar lunged at scientist Rodrigo Nuñez, who had just injected him with a needle attached to a bamboo stick. But the cable snare around his front paw held, and the jaguar rapidly succumbed to the sedative, allowing Rodrigo to check his health and fit him with a GPS collar. Rodrigo has dedicated his life to protecting jaguars. In the state of Nayarit in western Mexico, numbers of jaguars are decreasing alarmingly, mainly because of hunting. Many bullets were buried in this jaguar's side, and two of his teeth had been shattered after he had been shot in the face. Rodrigo tracked this jaguar for five months – and then the collar stopped transmitting. He presumes the jaguar was killed by hunters, who then destroyed the collar.

Canon EOS 5D Mark II + 16-35mm f2.8 lens; 1/125 sec at f4; ISO 3200.

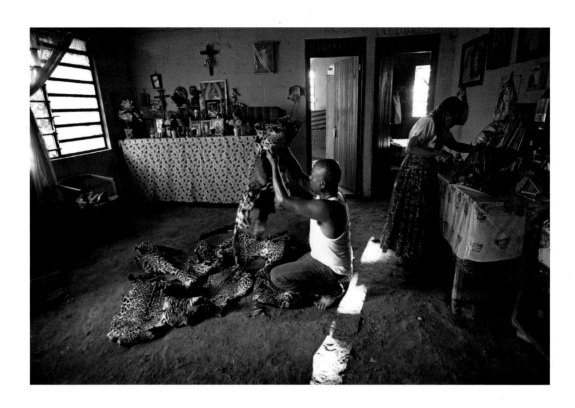

Remains of the past

There were eight jaguar skins among the pelts in this house, in a small town in the forested state of Campeche on the Yucatán Peninsula. While the market for pelts has fallen in the wake of anti-fur campaigns, the demand for paws and teeth (for jewellery) continues, and jaguar bone is starting to augment tiger bone in traditional Asian medicine. Those involved in the illegal trade have little to fear from the law, unless they are caught in the actual act of killing a jaguar. Conservationists concentrate on habitat protection, education, ecotourism, sustainable development, cultural respect and community support. As a member of the Jaguar Alliance, Alejandro uses his images to give talks to communities in small towns. 'I try to change the ideology that glorifies hunting.'

Canon EOS 5D Mark II + 16-35mm f2.8 lens; 1/160 sec at f5; ISO 400.

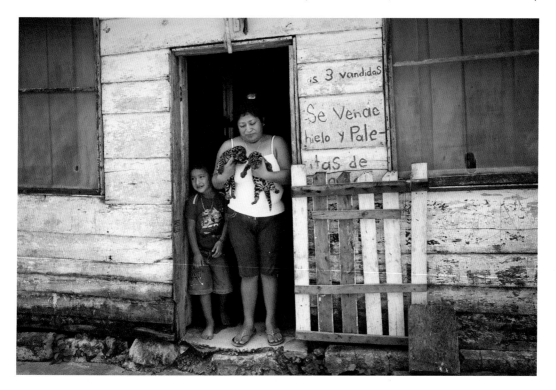

Hope for the future

Two four-week-old female jaguar cubs are about to be handed over to the authorities in a small jungle town on the Yucatán Peninsula, southern Mexico. A poacher probably killed their mother and sold the cubs to this woman. They were lucky to have survived without their mother's milk, since jaguars suckle their cubs for five to six months. Young jaguars also stay with their mothers until they are about two years old and have learnt to hunt. These cubs were taken to a jaguar refuge that specializes in keeping animals as wild as possible, training them to hunt. The pair are now nearly two years old and so ready to be released if suitable protected forest can be found. Much of jaguar habitat is fragmented so keeping jaguar highways open between populations is vital.

Canon EOS 5D Mark II + 16-35mm f2.8 lens; 1/4000 sec at f4.5; ISO 800.

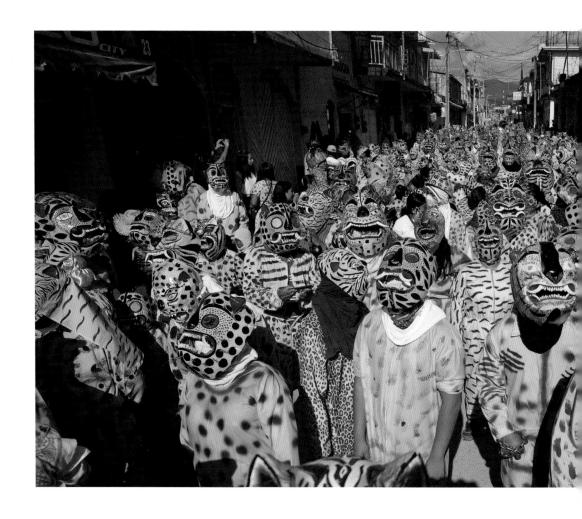

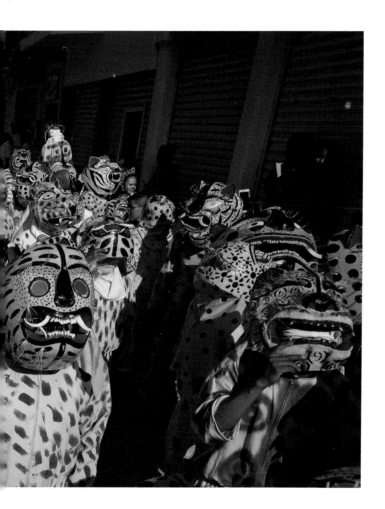

Jaguars come to town

More than 1,000 people parade in vibrant fancy dress to celebrate the jaguar. The Tigrada festival is held every August in Chilapa de Alvarez, an ancient town in the southwestern state of Guerrero. The participants make their own wooden masks, mostly decorated with peccary teeth and hair and with mirrors for eyes. The parade, the music and the dances invoke the Aztec god Tepeyollotl, represented by a jaguar, calling for more rain and abundant crops. The festival is called Tigrada because sixteenth-century Spaniards, who had never encountered jaguars, called them tigers. The jaguar has long been a major element of Mexican culture and mythology, featuring heavily in the art and artefacts of the ancient civilizations of the Aztecs, Mayans and Olmecs. Today, La Tigrada is the biggest celebration of an animal in Mexico. But the jaguar itself is extinct in this particular region.

Canon EOS 5D Mark II + 16-35mm f2.8 lens; 1/5000 sec at f6.3; ISO 800.

Rising Star

Demonstrating style and artistic intent, this award is given to a photographer aged 18–26 years old. Winning this category for the second time, Michel d'Oultremont has produced a visually stunning portfolio, each image drawing out the personality of its subject.

Dream duel

Michel d'Oultremont

BELGIUM

As storm clouds gathered over the Ardennes forest in Belgium, Michel hid behind a tree under a camouflage net. It was the best spot for viewing any action on the ridge – a place he knew well – but he needed luck for all the elements to come together. The thrilling sound of two red deer stags, roaring in competition over females, echoed through the trees, but infuriatingly the action was taking place further down the slope. Well matched, neither challenger was giving way, and the contest escalated into a noisy clash of antlers. For years, Michel had wanted to picture this highlight of the rut in the dramatic light of dusk, but the stags were never in quite the right place at the right time. At last, the stags appeared on the ridge, antlers locked, silhouetted. Michel had time to capture the clash – through branches of the tree to create the atmosphere – before the light faded and he had to leave the fighters, still locked in battle.

Canon EOS 5D Mark IV + 400mm f2.8 lens + 2x extender; 1/400 sec at f8; ISO 400; Gitzo tripod + Uniqball head.

There is obvious purpose behind this collection – to create intimate glimpses of nature that have mystery, that are openings to stories. Without doubt it's the work of someone with a true love of nature.

Roz Kidman Cox

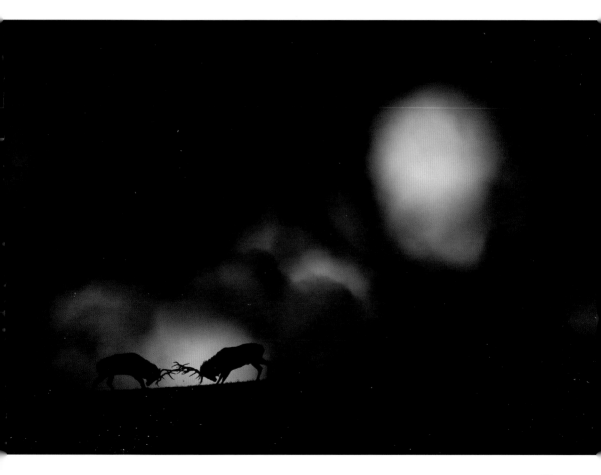

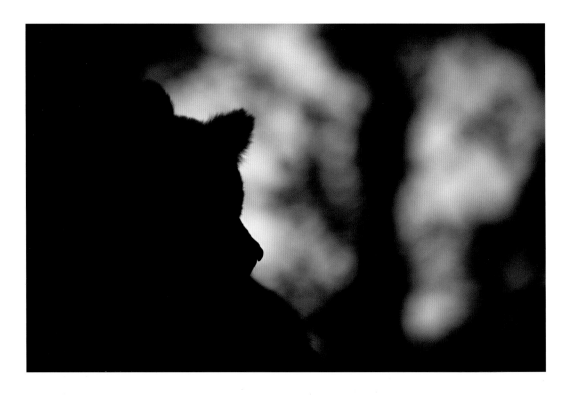

Night of the bear

On a mild summer night in the mountains of Risnjak National Park, Croatia, a brown bear emerged from the forest shadows into a small clearing. Crouched under a nearby bush beneath his camouflage net, Michel's plan – inspired by his love of Chinese shadow puppets – was to photograph a bear in its forest environment, backlit with natural light. For a while, the bear remained cloaked in darkness, quietly eating berries and grass (staple foods for brown bears, though they are opportunistic feeders and enjoy a varied, omnivorous diet). Michel's patience was rewarded when the bear raised its head, revealing its classic profile against the soft light. 'I loved being alone with the bear,' he says, a sentiment reflected in his intimate portrait, framed by the branches beyond.

Canon EOS 5D Mark II + 400mm f2.8 lens; 1/8000 sec at f2.8; ISO 500; Gitzo tripod + Uniqball head.

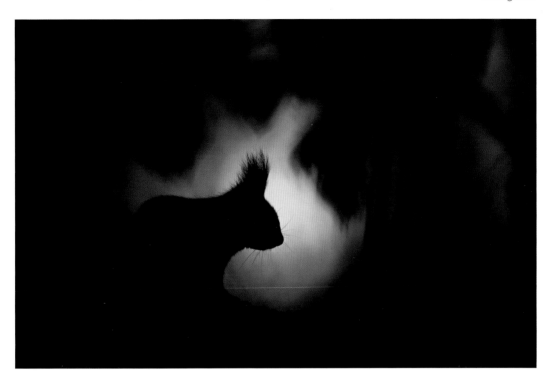

Dawn of the squirrel

It was Michel's fondness for red squirrels that prompted him to lie on the forest floor on a dark winter morning. From beneath his camouflage net, he had his eye on one squirrel in particular. Each morning, it took the same route through a woodland near Michel's home in Brussels. Rather than hibernating, red squirrels spend the winter scurrying around in search of food, relying on stores they have built up in autumn to see them through lean times. To encourage it to pause, Michel used nuts. 'After a few days, it paused exactly where I wanted it to, on a fallen branch,' he says. The squirrel eventually obliged with a side-on stance positioned against the leafy window behind, allowing Michel to take its portrait, edged in gentle dawn light, highlighting its whiskers and distinctive tufted ears.

Canon EOS-1D X Mark II + 400mm f2.8 lens; 1/1600 sec at f3.2; ISO 320.

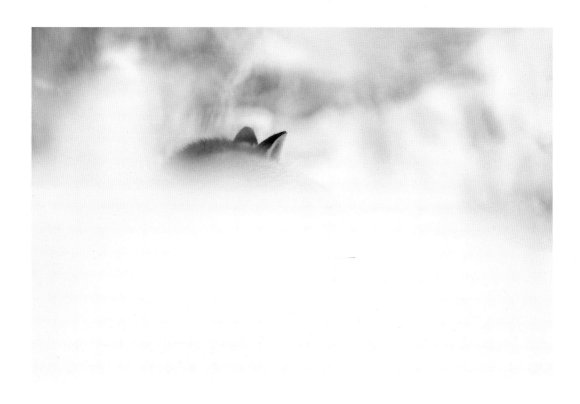

Snow snooze

Michel is passionate about not disturbing his subjects. In the Belgian Ardennes, he spotted a red fox sleeping in the snow near its den. He approached metre by metre, finally crawling so as not to wake it. Isolating his subject with a long lens, blurring the background, Michel created a simple, dreamy portrait – just two black-backed ears and a hint of warm, orange fur, nestled in a cloud of white – a peek into the fox's private world. 'I stayed with him for a sublime 10 minutes,' says Michel. 'He twitched his ears from time to time but never once woke up.'

Canon EOS 5D Mark III + 400mm f2.8 lens; 1/1600 sec at f2.8; ISO 250.

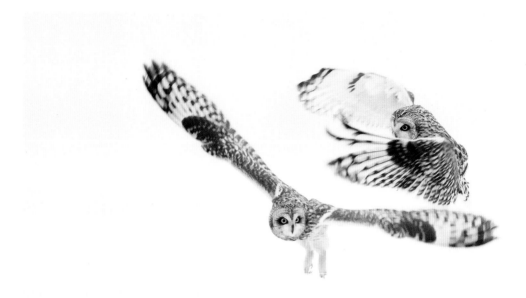

Silent skirmish

In a winter white-out, two short-eared owls squabble over a mouse caught by the larger one. In Cambrai, northern France, Michel had waited eight days for snow, hoping to use it as a backdrop for a hunting owl (the owl's mottled plumage usually camouflages it against vegetation). But he hadn't expected a clash of neighbours. Skilled hunters, short-eared owls detect their prey – small mammals and sometimes birds – mainly by sound, flying almost silently over open country. As the owls showed off their aerial agility, Michel – shooting from his car – focused on their piercing yellow eyes, boldly framed in black. He got his picture, but the contest had no victor. 'The mouse fell and escaped alive.'

Canon EOS 5D Mark III + 500mm f4 lens; 1/640 sec at f4.5; ISO 1250.

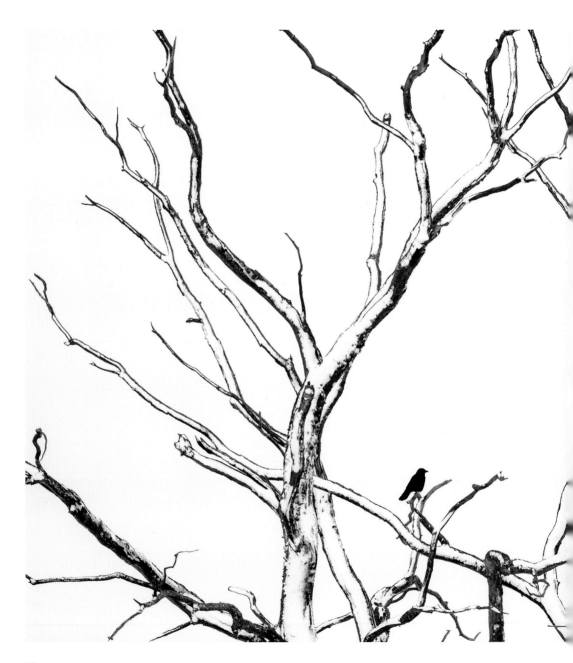

Winter lattice

Out looking for foxes in the snow around Lescheret, Belgium, Michel was drawn to the graphic design of this dead tree. Its dark branches – dusted white by a recent blizzard – stood out against the colourless sky. A solitary carrion crow alighted on one of the lower limbs. Though sometimes forming communal roosts in winter, this corvid is most often found alone or in pairs (which form for life). Carrion crows are smart – both in looks and brains. From a distance, they appear entirely black, but close up, their plumage shimmers with a green and purple gloss. They are known to bury food to eat later and sometimes to drop hard-shelled items from a height to crack them and get at the snacks within. Michel was quick to spot the crow's potential in his picture. He framed it centrally, to give maximum impact to the texture and pattern of branches and create a painterly image of simplicity in black and white.

Canon EOS 5D Mark IV + 400mm f2.8 lens; 1/2500 sec at f4; ISO 400.

Young Photographers

The Young Wildlife Photographer of the Year 2018 is Skye Meaker – the winning photographer whose picture has been judged to be the most memorable of all the pictures by photographers aged 17 and under.

Lounging leopard

Skye Meaker
SOUTH AFRICA

Mathoja was dozing when they finally found her, lying along a low branch of a nyala tree. And she continued to doze all the time they were there, unfazed by the vehicle. 'She would sleep for a couple of minutes. Then look around briefly. Then fall back to sleep,' says Skye. Mathoja's home is Botswana's Mashatu Game Reserve, which Skye and his family regularly visit, always hoping to see leopards, though they are notoriously elusive. In Bantu language, Mathoja means 'the one that walks with a limp'. Skye calls her Limpy. She limps because of an injury as a cub, but otherwise she is now a healthy eight-year-old, and she remains the calmest of leopards around vehicles. Though she dozed just metres away from Skye, she blended into the background, the morning light was poor, leaves kept blowing across her face, and her eyes were only ever open briefly, making it hard for Skye to compose the shot he was after. Finally, just as she opened her eyes for a second, the overhead branches moved enough to let in a shaft of light that gave a glint to her eyes, helping him to create his memorable portrait.

Canon EOS-1D X + 500mm f4 lens; 1/80 sec at f4; ISO 1250.

Skye Meaker

Brought up in South Africa, in a family with a love for nature and photography, Skye has been taking pictures since he was seven years old. Now 15, he has already won prizes for his work and is determined to keep learning and to make wildlife photography his lifelong vocation.

It's an intimate portrait, carefully framed and beautifully exposed. The natural lighting and dappled shade gives atmosphere, and the photographer has caught the exact moment when the leopard has opened her eyes for a second and is gazing into the distance as if in contemplation.

Roz Kidman Cox

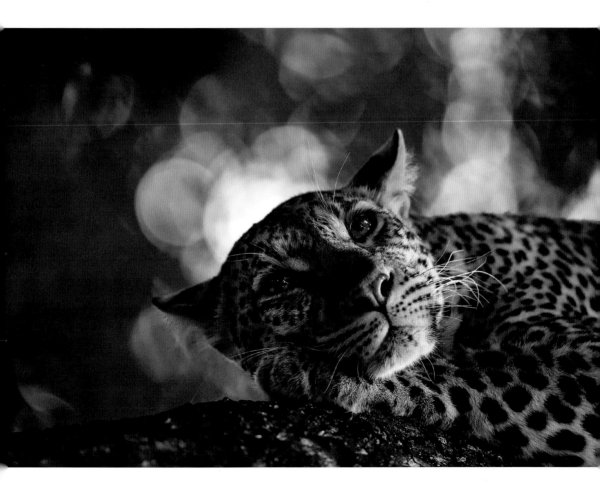

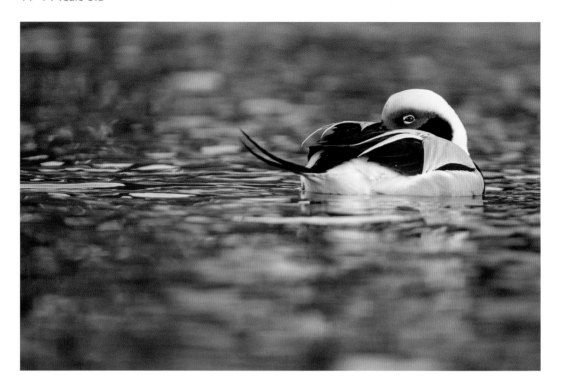

Duck of dreams

Carlos Perez Naval
SPAIN

The long-tailed ducks were the most beautiful Carlos had ever seen. And it had been the sea ducks that he most wanted to see when the family planned their holiday to Norway. They were staying on the Varanger Peninsula, on the northern coast of the Barents Sea. But to get close enough to photograph the ducks meant booking a floating hide in the harbour and arriving before sunrise. As the light broke, the ducks flew in. An overcast sky muted the dawn light and allowed Carlos to capture the subtle colours of the duck's plumage, and reflected lights from the village added a golden sparkle to the ripples, caught in a perfect frame.

Nikon D7100 + 200-400mm f4 lens at 400mm; 1/320 sec at f4; ISO 1000.

It takes great skill to achieve such a powerful balance of light, patterns, and behaviour; a perfect portrait of a beautiful animal, watchful, yet undisturbed.

Alex Badyaev

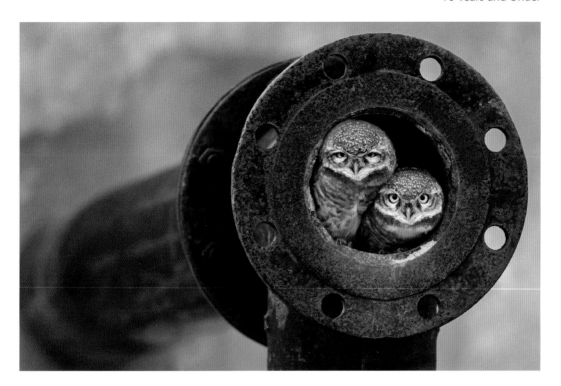

Pipe owls

Arshdeep Singh
INDIA

Huddled together at the opening of an old waste-pipe, two spotted owlets look straight into Arshdeep's lens. He and his father had been driving out of Kapurthala, a city in the Indian state of Punjab, going on a birding trip, when he saw one of them dive into the pipe. His father didn't believe what he'd seen but stopped the car and backed up. It wasn't long before one of the owlets popped its head out. Guessing this might be a nest site, Arshdeep begged to borrow his father's camera and telephoto lens. Resting the lens on the car's half open window he created a characterful portrait of a species that has adapted to urban life.

Nikon D500 + 500mm f4 lens; 1/1600 sec at f4 (-0.7 e/v); ISO 450.

Original, delightful and cleverly framed – an alert observation leading to a memorable image.

Roz Kidman Cox

People's Choice

Only 100 competition images can be selected, but many more deserve to be seen. A further 25 unforgettable shots from this year's entries have been chosen by the Natural History Museum.

Shy

Pedro Carrillo
SPAIN

The mesmerizing pattern of a beaded sand anemone beautifully frames a juvenile Clarkii clownfish in Lembeh strait, Sulawesi, Indonesia. Known as a 'nursery' anemone, it is often a temporary home for young clownfish until they find a more suitable host anemone for adulthood.

Nikon D4 +Nikkor 70-180mm f4.5-5.6 D ED AF Micro lens at 78mm; 1/250 sec at f16; ISO 100; Seacam housing; two Seacam Seaflash 150TTL.

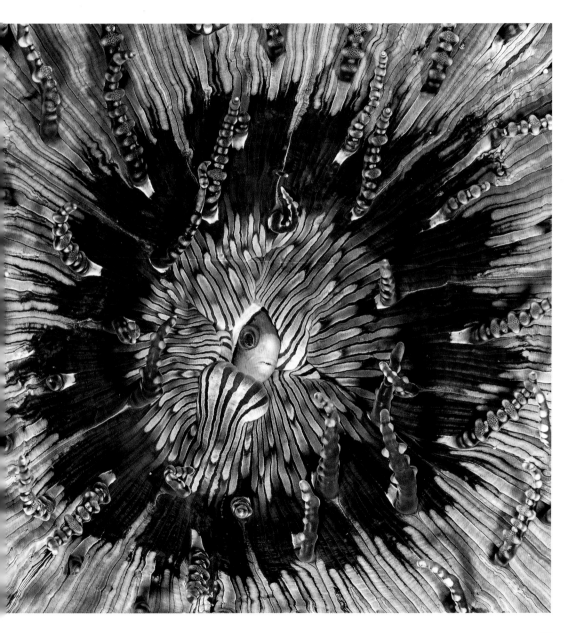

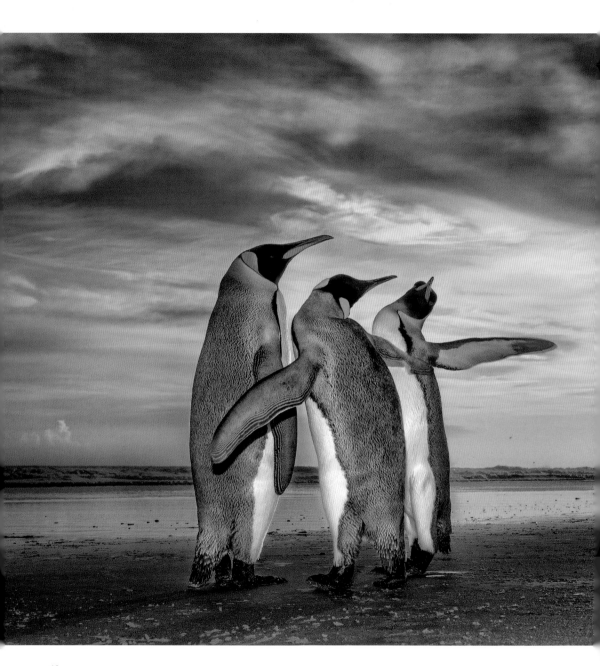

Three kings

Wim Van Den Heever
SOUTH AFRICA

Wim came across these king penguins on a beach in the Falkland Islands just as the sun was rising. They were caught up in a fascinating mating behaviour – the two males were constantly moving around the female using their flippers to fend the other off.

Nikon D810 + Nikon 24-70mm f2.8 lens at 40mm; 1/250sec at f11; Nikon SB910 flash.

Teenager

Franco Banfi
SWITZERLAND

Franco was free diving off Dominica in the Caribbean Sea when he witnessed this young male sperm whale trying to copulate with a female. Unfortunately for him her calf was always in the way and the frisky male had to continually chase off the troublesome calf.

Canon 1DX Mark II + 8-15mm f/4 lens; 1/100 sec at f16; ISO 640; Seacam housing.

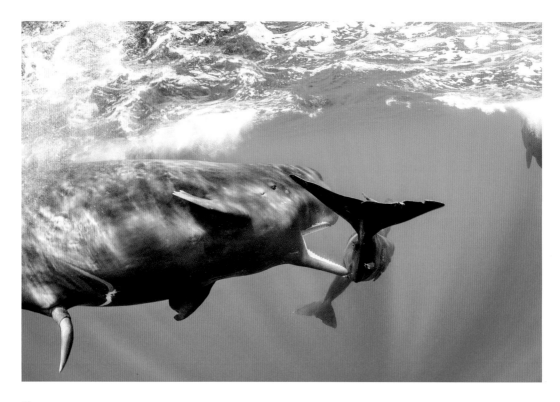

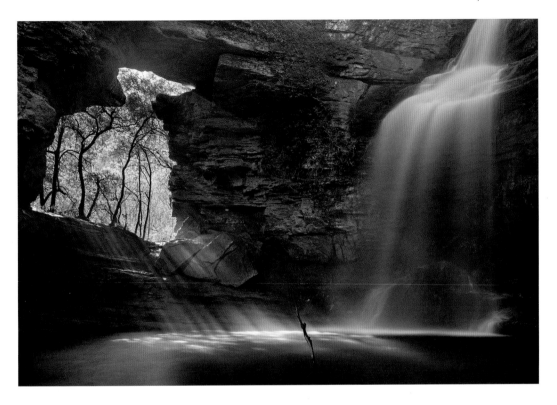

Painted waterfall

Eduardo Blanco Mendizabal

SPAIN

When the sun beams through a hole in the rock at the foot of the La Foradada waterfall, Catalonia, Spain, it creates a beautiful pool of light. The rays appear to paint the spray of the waterfall and create a truly magical picture.

Canon 5D Mark III + 24-105mm f.4 lens; 30 sec at f9; grey neutral filter, tripod.

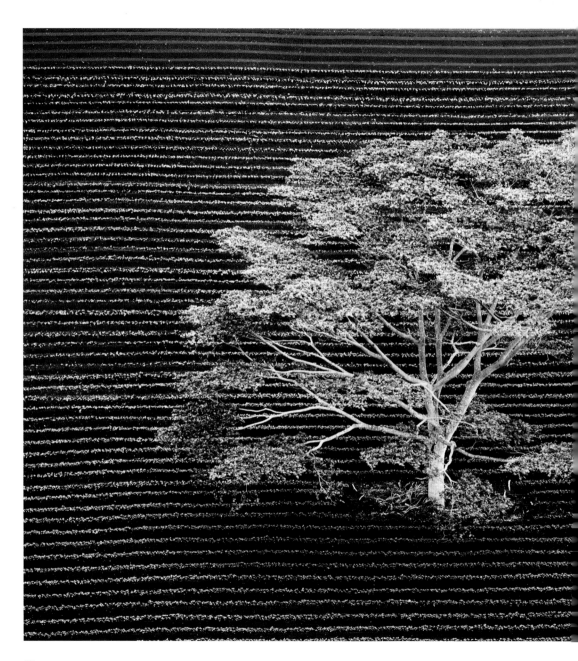

Isolated

Anna Henly

UK

Snapped from a helicopter, this isolated tree stands in a cultivated field on the edge of a tropical forest on Kauai, Hawaii. The manmade straight lines of the ploughed furrows are interrupted beautifully by nature's more unruly wild pattern of tree branches.

Canon EOS 5D Mark II + EF70-200mm f/2.8 L IS USM lens used at 130mm; 1/2500 sec at f2.8; ISO 400.

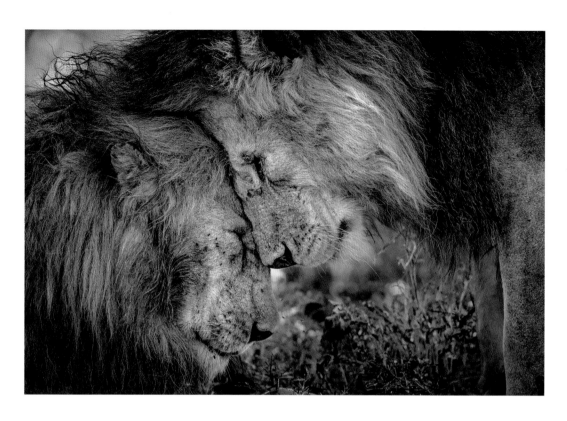

Bond of brothers

David Lloyd
NEW ZEALAND/UK

These two adult males, probably brothers, greeted and rubbed faces for 30 seconds before settling down. Most people never have the opportunity to witness such animal sentience, and David was honoured to have experienced and captured such a moment.

Nikon D800E + 400mm f/2.8 lens; 1/500th sec at f4.8, ISO 500.

Resting mountain gorilla

David Lloyd
NEW ZEALAND/UK

The baby gorilla clung to its mother whilst keeping a
curious eye on David. He had been trekking in South
Bwindi, Uganda, when he came across the whole family.
He followed them and they then stopped in a small
clearing to relax and groom each other.

Nikon D500 + 300mm f/4 lens; 1/350th sec at f9.5; ISO 5600.

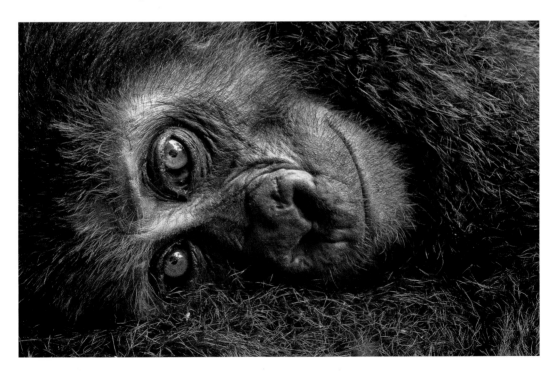

Clam close-up

David Barrio

SPAIN

This macro-shot of an iridescent clam was taken in the Southern Red Sea, Marsa Alam, Egypt. These clams spend their lives embedded amongst stony corals, where they nest and grow. It took David some time to approach the clam, fearing it would sense his movements and snap shut!

Nikon D7100-105mm lens + Saga 10 diopters wet lens; 1/180 sec at f27; ISO 200; Isotta housing; 2xStrobes.

Sound asleep

Tony Wu

USA

This adult humpback whale balanced in mid-water, head-on and sound asleep was photographed in Vava'u, Kingdom of Tonga. The faint stream of bubbles, visible at the top, is coming from the whale's two blowholes and was, in this instance, indicative of an extremely relaxed state.

Canon 5D Mark III + Canon 15mm f2.8 fisheye lens; 1/200 sec at f10; ISO640; Zillion housing; Pro-One dome port.

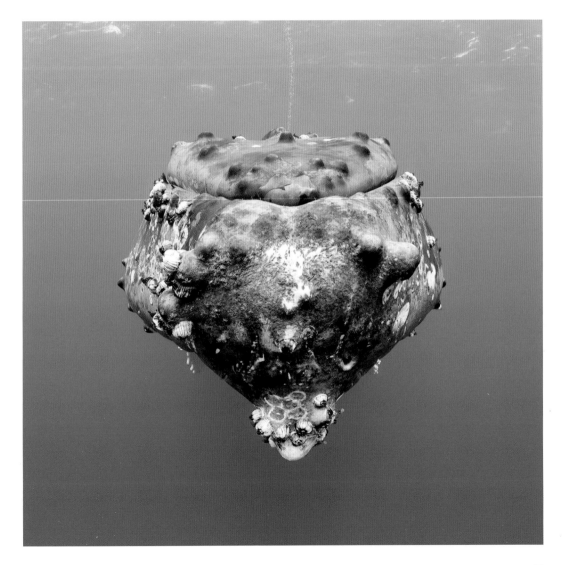

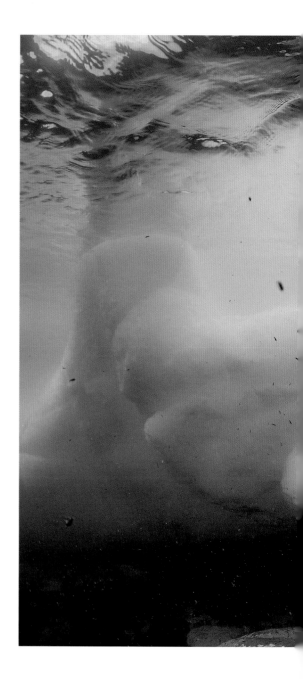

Curious encounter

Cristobal Serrano

SPAIN

Any close encounter with an animal in the vast wilderness of Antarctica happens by chance, so Cristobal was thrilled by this spontaneous meeting with a crabeater seal off of Cuverville Island, Antarctic Peninsula. These curious creatures are protected and, with few predators, thrive.

Canon EOS 5D Mark IV + Canon EF 8-15mm f4L Fisheye USM lens; 1/250 sec at f8; ISO 160; Seacam housing and flash.

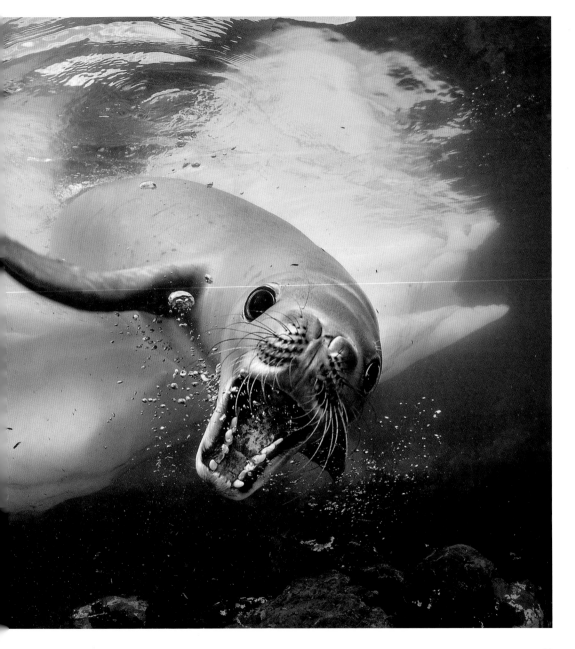

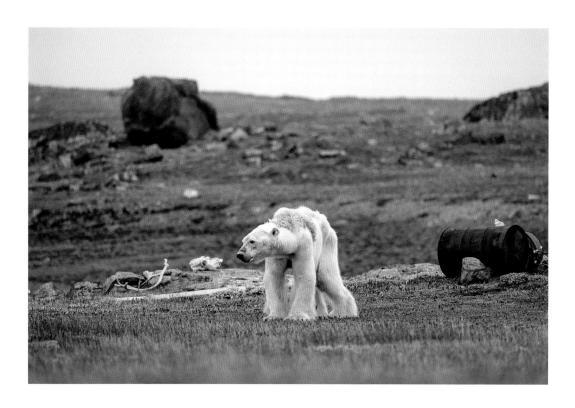

A polar bear's struggle

Justin Hofman

USA

Justin's whole body pained as he watched this starving polar bear at an abandoned hunter's camp, in the Canadian Arctic, slowly heave itself up to standing. With little, and thinning, ice to move around on, the bear is unable to search for food.

Sony a7R II + Sony FE 100-400mm f4.5-5.6 GM OSS lens; 1/200 sec at f10; ISO 800.

Ice and water

Audun Lie Dahl

NORWAY

The Bråsvellbreen glacier moves southwards from one of the ice caps covering the Svalbard Archipelago, Norway. Where it meets the sea, the glacier wall is so high that only the waterfalls are visible, so Audun used a drone to capture this unique perspective.

DJI Phantom 4 pro + 24mm lens; 1/120 sec at f 6.3; ISO 100. Panorama of 3 images.

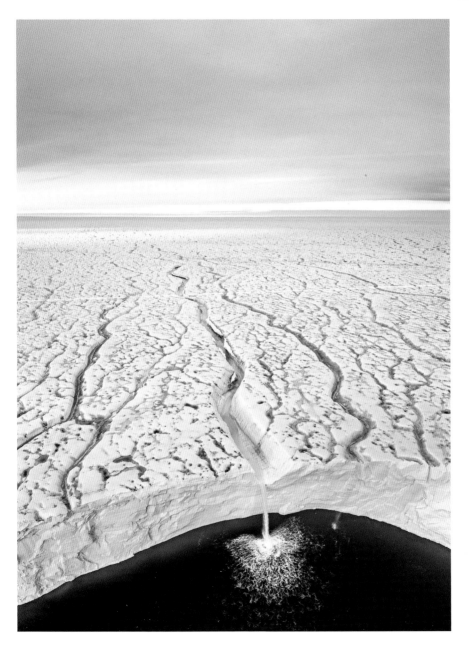

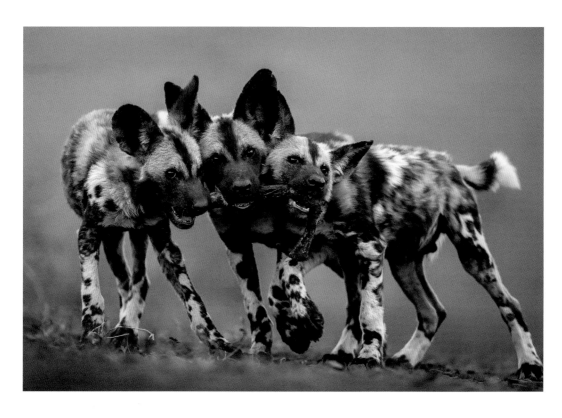

One toy, three dogs

Bence Mate

HUNGARY

While adult African wild dogs are merciless killers, their
pups are extremely cute and play all day long. Bence
photographed these brothers in Mkuze, South Africa –
they all wanted to play with the leg of an impala and were
trying to drag it in three different directions!

**Canon EOS-1DX Mark II; 200-400mm lens (35mm equivalent:
197.2-394.3 mm); 1/1800 sec at f4.0; 4000 ISO.**

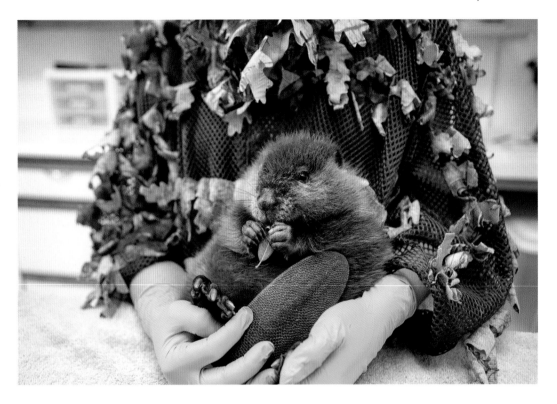

The orphaned beaver

Suzi Eszterhas

USA

A one-month-old orphaned North American beaver kit is held by a caretaker at the Sarvey Wildlife Care Center in Arlington, Washington. Luckily it was paired with a female beaver who took on the role of mother and they were later released into the wild.

Canon 1DX + 24-70mm f2.8 lens; 1/200 sec at f3.5; ISO 1600.

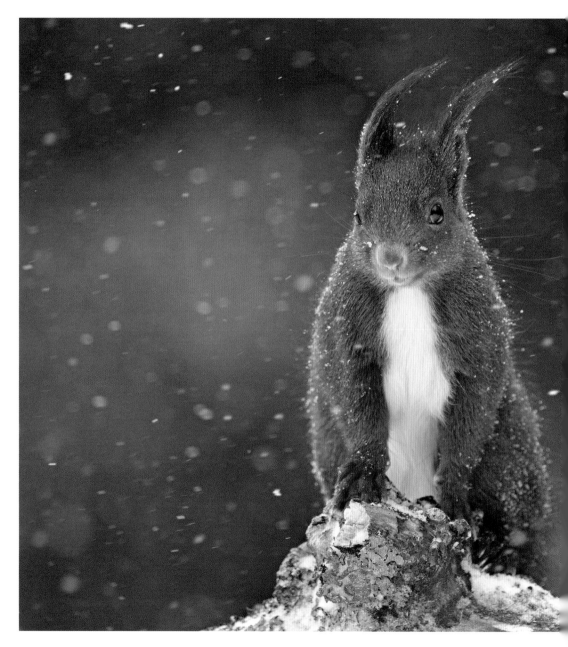

Under the snow

Audren Morel

FRANCE

Unafraid of the snowy blizzard, this squirrel came to visit Audren as he was taking photographs of birds in the small Jura village of Les Fourgs, France. Impressed by the squirrel's endurance, he made it the subject of the shoot.

Nikon D7200 + Nikon 300mm f4 lens; 1/1600 sec at f4 (-0.7e/v); ISO 500.

Red, silver and black

Tin Man Lee

USA

Tin was fortunate enough to be told about a fox den in Washington State, North America, which was home to a family of red, black and silver foxes. After days of waiting for good weather he was finally rewarded with this touching moment.

Canon 1DX Mark II +600mm f4 lens; 1.4x teleconverter; 1/1600 sec at f11; ISO 2000.

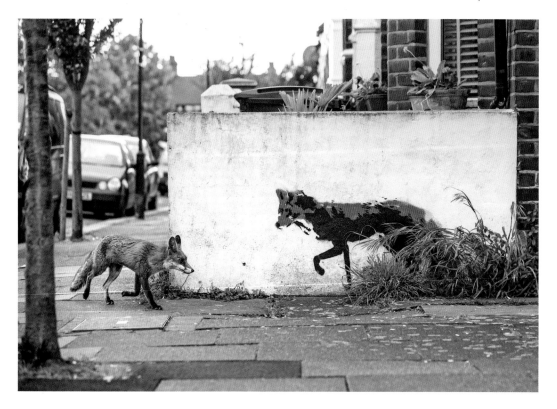

Fox meets fox

Matthew Maran

UK

Matthew has been photographing foxes close to his home in north London for over a year, and ever since spotting this street art, had dreamt of capturing this image. After countless hours, and many failed attempts, his persistence paid off.

Canon EOS 5D Mark III + 70-200mm f2.8 IS II USM lens; 1/500 sec at f4.0; ISO 800.

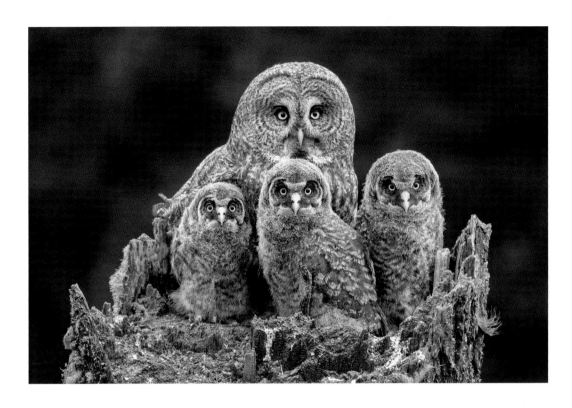

Family portrait

Connor Stefanison

CANADA

A great grey owl and her chicks sit in their nest in the
broken top of a Douglas fir tree in Kamloops, Canada. They
looked towards Connor only twice as he watched them
during the nesting season from a tree hide 15 metres
(50 feet) up.

**Canon 1D Mark IV + Canon 500mm f4 IS lens; 1/200 sec at
f7.1; ISO 1250; Manfrotto monopod.**

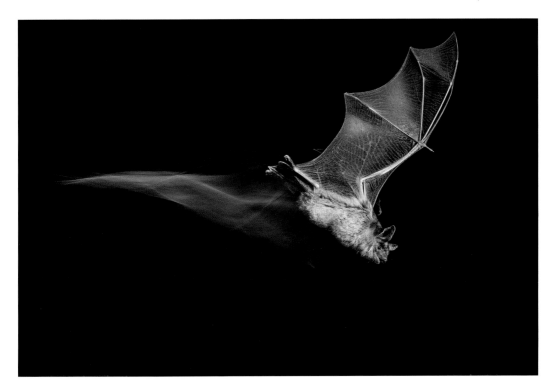

The bat's wake

Antonio Leiva Sanchez
SPAIN

After several months of field research into a little colony of greater mouse-eared bats in Sucs, Lleida, Spain, Antonio managed to capture this bat mid-flight. He used a technique of high speed photography with flashes combined with continuous light to create the 'wake'.

Canon7D Mark II + Tamron 18-270mm f3.5-6.3 lens; 1/13 sec at f10; ISO 200; Infrared barrier; Metz 58 AF-1 flash; E-TTL flash cable.

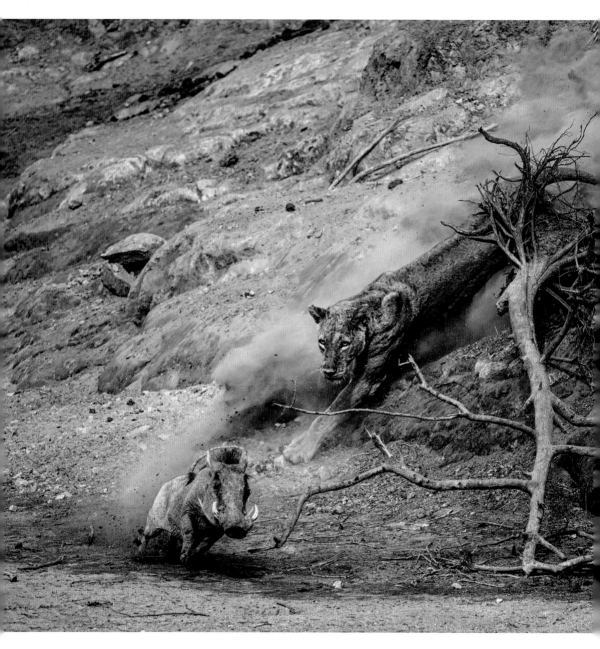

Ambush

Federico Veronesi

KENYA

On a hot morning at the Chitake Springs, in Mana Pools National Park, Zimbabwe, Federico watched as an old lioness descended from the top of the riverbank. She'd been lying in wait to ambush any passing animals visiting a nearby waterhole further along the riverbed.

Nikon D810 + 400mm f2.8 lens; 1/1000 sec at f5 (-1e/v); ISO 140.

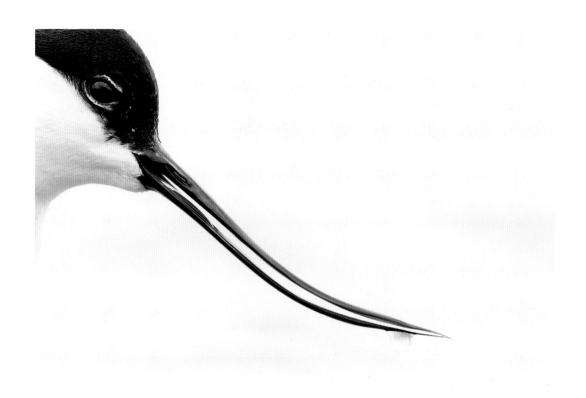

Unique bill

Rob Blanken

THE NETHERLANDS

The pied avocet has a unique and delicate bill, which it
sweeps like a scythe as it sifts for food in shallow brackish
water. This stunning portrait was taken from a hide in the
northern province of Friesland in The Netherlands.

**Nikon D500 + AF-S Nikkor 200-500mm f1:5.6 E ED lens at
250mm; 1/200 sec at f6 (+ 2 2/3); ISO 800.**

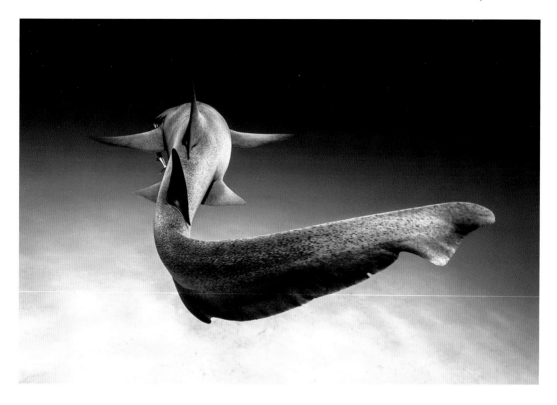

Gliding

Christian Vizl

MEXICO

With conditions of perfect visibility and beautiful sunlight, Christian took this portrait of a nurse shark gliding through the ocean off the coast of Bimini in the Bahamas. Typically these sharks are found near sandy bottoms where they rest, so it's rare to see them swimming.

Canon 5D Mark II + 16-35mm f2.8 lens; 1/200 sec at f9; ISO 200; Aquatica housing.

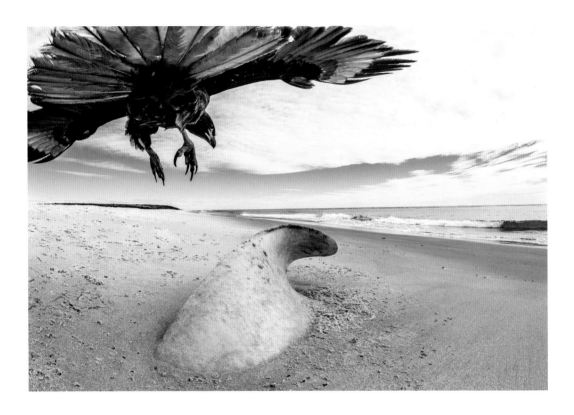

All that remains

Phil Jones

UK

A male orca had beached itself about a week before Phil's visit to Sea Lion Island, Falkland Islands. Despite its huge size the shifting sands had almost covered the whole carcass and scavengers, such as this striated caracara, had started to move in.

Canon 1Dx Mark I + Canon 15mm f2.8 fisheye lens; 1/1250 sec at f16; ISO 1600; Joby gorillapod; Hahnel wireless remote shutter release.

The extraction

Konstantin Shatenev

RUSSIA

Hundreds of Steller's sea eagles gather on the north-eastern coast of Hokkaido, Japan, during their winter migration from Russia, searching for food among the floating ices floes and along the sea coast. Konstantin took this image from a boat with the help of bait.

Canon1DX + EF300 f4IS USM lens; 1/1250 sec at f13; ISO800.

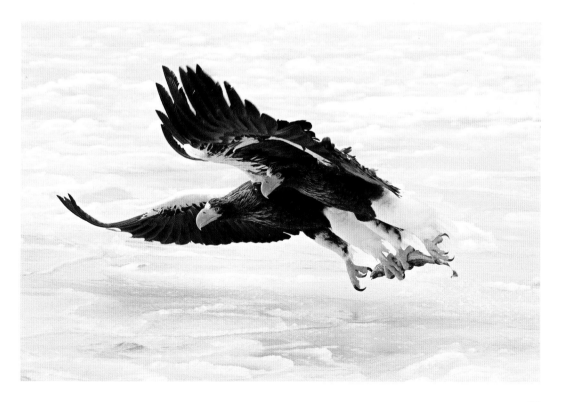

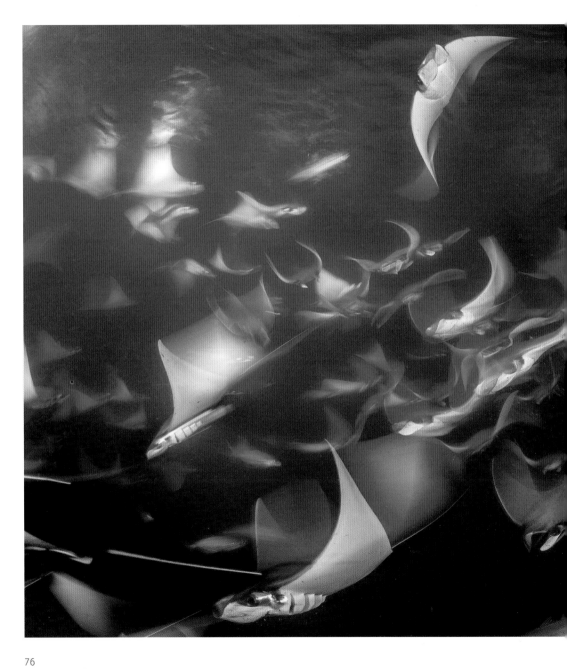

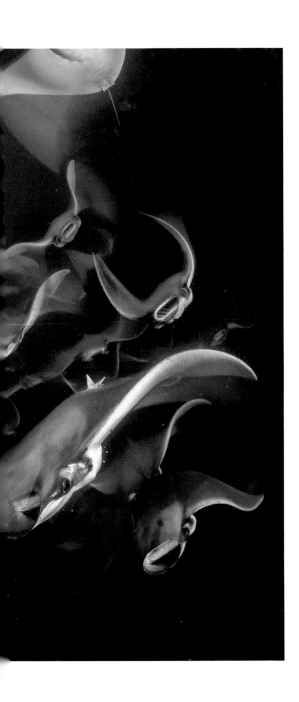

Otherworldly

Franco Banfi

SWITZERLAND

A school of Munk's devil ray were feeding on plankton at night off the coast of Isla Espíritu Santo in Baja California, Mexico. Franco used the underwater lights from his boat and a long exposure to create this otherworldly image.

Canon 5DS + 8-15mm f/4 lens; 1/4 sec at f11; ISO 160; Isotta housing; Seacam Seaflash 150; two strobes.

Index of Photographers

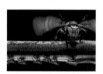

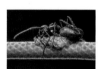

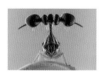

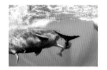

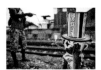

26
Joan de la Malla Gomez
SPAIN
www.joandelamalla.com

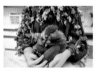

63
Suzi Eszterhas
USA
www.suziesterhas.com
Agent
https://www.mindenpictures.com/

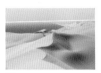

20
Orlando Fernandez Miranda
SPAIN
www.orlandomiranda.com

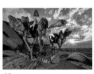

18
Jen Guyton
GERMANY/USA
www.jenguyton.com
Agent
www.naturepl.com

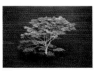

52
Anna Henly
UK
www.annahenly.com

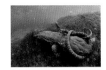

14
David Herasimtschuk
USA
www.davidherasimtschuk.com
www.freshwatersillustrated.org

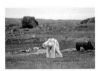

60
Justin Hofman
USA
www.Justin-Hofman.com

74
Phil Jones
UK
www.philjonesphotography.com

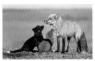

66
Tin Man Lee
USA
https://tinmanlee.com

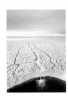

61
Audun Lie Dahl
NORWAY
www.wildphoto.no

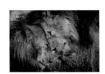

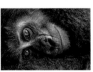

54, 55
David Lloyd
NEW ZEALAND/UK
www.davidlloyd.net

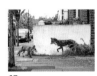

67
Matthew Maran
UK
info@matthewmaran.com
www.matthewmaran.com

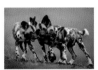

62
Bence Mate
HUNGARY
https://bencemateshides.com/

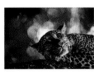

42
Skye Meaker
SOUTH AFRICA
emeaker@webstorm.co.za
www.skyemeaker.com

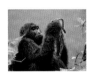

64
Audren Morel
FRANCE
http://audrenmorel.piwigo.com

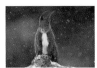

16
Ricardo Núñez Montero
SPAIN
www.ricardonmphotography.com

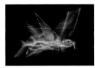

24
Michael Patrick O'Neill
USA
www.mpostock.com

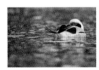

44
Carlos Perez Naval
SPAIN
enavalsu@gmail.com
www.carlospereznaval.wordpress.
com

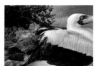

15
Thomas P Peschak
GERMANY/SOUTH AFRICA
www.thomaspeschak.com
Agent
www.natgeocreative.com

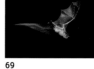

69
Antonio Leiva Sanchez
SPAIN
toleisan@hotmail.com

19, 23, 58
Cristobal Serrano
SPAIN
www.cristobalserrano.com

75
Konstantin Shatenev
RUSSIA
shatenev007@mail.ru
www.shatenev.com

45
Arshdeep Singh
INDIA
info@arshdeep.in
www.arshdeep.in

68
Connor Stefanison
CANADA
www.connorstefanison.com

17
Georgina Steytler
AUSTRALIA
www.georginasteytler.com.au

48
Wim van den Heever
SOUTH AFRICA
www.wimvandenheever.com

22
Jan van der Greef
THE NETHERLANDS
www.janvandergreef.com

6
Marsel van Oosten
THE NETHERLANDS
www.squiver.com

70
Federico Veronesi
KENYA
www.federicoveronesi.com

73
Christian Vizl
MEXICO
www.christianvizl.com

57
Tony Wu
USA
www.tony-wu.com

27–33
Alejandro Prieto
MEXICO
www.alejandroprietophotography.com